Here Sister, LET ME HELP YOU UP

MESSAGES of SISTERHOOD, SELF-CARE, and BODY LOVE

STEPHANIE CHINN

CASTLE POINT BOOKS

NEW YORK

For information, address St. Martin's Press, 120 Broadway, New York, NY 10271.
www.castlepointbooks.com

The Castle Point Books trademark is owned by Castle Point Publishing, LLC.
Castle Point books are published and distributed by St. Martin's Publishing Group.

ISBN 978-1-250-27644-5 (paper-over-board)

Design by Katie Jennings Campbell
Illustrations by Stephanie Chinn

Our books may be purchased in bulk for promotional, educational, or business use.
Please contact your local bookseller or the Macmillan Corporate and Premium Sales Department at
1-800-221-7945, extension 5442, or by email at MacmillanSpecialMarkets@macmillan.com.

First Edition: 2021

10 9 8 7 6 5 4 3 2 1

to the generation before me—
MY MOM,
FOR ALWAYS REMINDING ME
that i can create the
WORLD I WANT FOR MYSELF.

and for LILLIAN:
EVERYTHING I DO
is to create the world that i
WOULD HAVE WANTED YOU
TO BE A PART OF.

WELCOME to a NEW VIEW

WHETHER YOU'VE BEEN TOLD YOU'RE TOO MUCH OR NOT ENOUGH, know that you're not alone. It's time to push aside those messages that hit you from all directions and even inside your own doubting mind. It's time to reclaim the truth of how glorious you are, just as you are, and live it out.

Moving to a new, trustworthy view of ourselves can be messy at first but so freeing in the end. To make the journey easier, carry the strength of sisters who support you and this truth with you always: only you get to decide what you believe about yourself. Then be gentle and patient with yourself. These beliefs won't switch overnight, but understanding that you are the one who ultimately gets to decide what you want to believe is the soil for beautiful seeds to grow.

Only you can change the story your head and heart take in each day. But together, we can build a community of sister support that makes it easier to find that truth—that you are the keeper of your own magic and the world needs you just as you were made to be. Every illustration and word in this book is designed to help you grow closer to yourself and your sisters around you and to remind you that when we lift ourselves up, we lift up those around us.

LET'S START THE IMPORTANT WORK HERE, AND KEEP UP THE CONVERSATION AND INSPIRATION ON INSTAGRAM: STEPHANIECHINNART.

MAKE SPACE *for* MAGIC

IN OUR MATERIAL WORLD, we often forget this simple, powerful truth: each and every one of us holds magic. We can become so wrapped up in thinking we need more of something—connections, notoriety, money—in order to make magic happen and realize our dreams. We buy crystals, good luck charms, and astral readings, trying to create a spark in our lives. While these kinds of tokens can be wonderful reminders of magic and possibilities, they don't bring us anything we don't already have deep within us. *We* are the magic we have been waiting for.

ALL WE NEED TO DO IS CREATE THE SPACE FOR OUR MAGIC TO COME UP AND SHINE HER LIGHT. SHE'S ALREADY IN US. WE DON'T NEED MORE MAGIC, WE JUST NEED TO REMEMBER HER.

THE MAGIC is ALREADY INSIDE of YOU

(YOU DON'T NEED MORE OF IT—YOU JUST NEED TO REMEMBER IT)

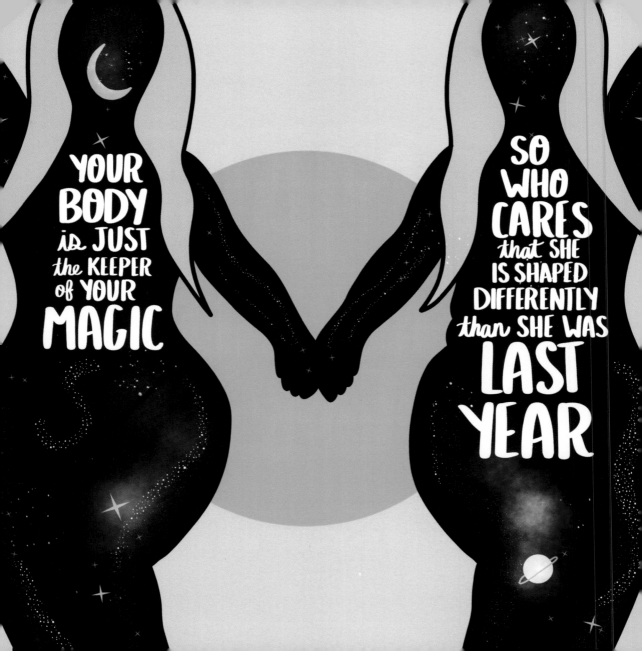

EMBRACE EVERY BODY

THOSE WHO GIVE BIRTH are surrounded by messaging to "get your body back" the moment they leave the hospital, and magazines make us believe our New Year's resolutions should center around making ourselves smaller. We are led by advertisers and media in general to work for some predetermined "desirable" size and shape from the time we are preteens until we are elders. Size-striving is not only physically exhausting but also mentally and emotionally draining. We can take a path to create a different world. What if, at the top of our resolution lists, we place our dreams and healthy goals—including supporting the bodies that take care of us in ways that our brains can't comprehend?

WHAT IF WE EMBRACE OUR VERY REAL AND PRESENT MAGIC IN EVERY STAGE INSTEAD OF CLINGING TO THE PAST (OR UNATTAINABLE) VERSIONS OF OURSELVES? JUST THINK OF THE POSSIBILITIES.

CONNECT WITH MESSENGERS *of* WORTH

WE LIVE IN A LOUD, FAST-MOVING, DIGITAL WORLD where anyone's opinion of us can land at our feet. If we are not careful, we may pick it up and take it in as truth—focusing on the thoughts and words of others who may not be aligned with the strength we need, in the way we need it shared. That's why one of the biggest acts of self-care we can take is building a village of supportive people around us and keeping that safety net close.

OUR LIVES WILL CHANGE WHEN WE SEEK OUT AND FIND PEOPLE WHO WILL ALWAYS REMIND US THAT WE ARE WORTHY OF LOVE AND CARE—EVEN ON DAYS WE MAY DOUBT IT OURSELVES.

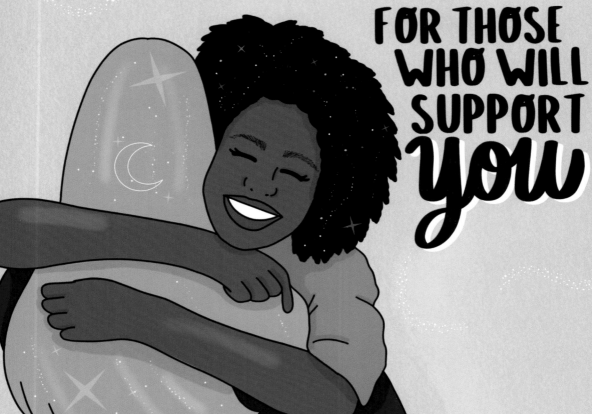

MOVE TOWARD SELF-LOVE

MOVEMENT IS SUCH A SACRED AND BEAUTIFUL THING. It shows us how capable our bodies are and offers numerous mental health benefits. However, it can also be used as a weapon against ourselves. Early in our lives, we may have picked up the idea that movement is only connected with the intent to lose weight. An unhealthy, unrealistic relationship with moving our bodies may grow. Instead of aspiring to move our bodies because it is good for our well-being, we can unconsciously strive to move our bodies to punish ourselves for what we have eaten. But we have the power to decouple movement from diet culture.

IF WE CAN PROMISE OUR BODIES, DAILY, THAT WE WILL USE MOVEMENT AS A MEANS TO FEEL GOOD AND AS A FORM OF SELF-LOVE, WE CAN NURTURE A HEALTHY RELATIONSHIP WITH THEM.

EXTEND *the* TABLE

SOMEWHERE ALONG THE WAY we get the idea that table space is limited and we're battling for the last seat. We start to believe that if there is space for her, there is no space for us. But this isn't a game of musical chairs or the truth in our lives. Not only does this view damage our relationships with each other, but it also limits us from seeing that there is always a seat for us at the table in whatever style fits us authentically and empowers us the most. Let's celebrate whenever another sister takes her own beautiful step and carry that energy into the steps we're dreaming of taking as well. We'll move forward together.

WE ARE NOT EACH OTHER'S COMPETITION, DESPITE WHAT THE MEDIA AND PATRIARCHY HAVE LED US TO BELIEVE. WE ARE EACH OTHER'S INSPIRATION AND REMINDERS OF WHAT CAN BE TRUE FOR US, TOO.

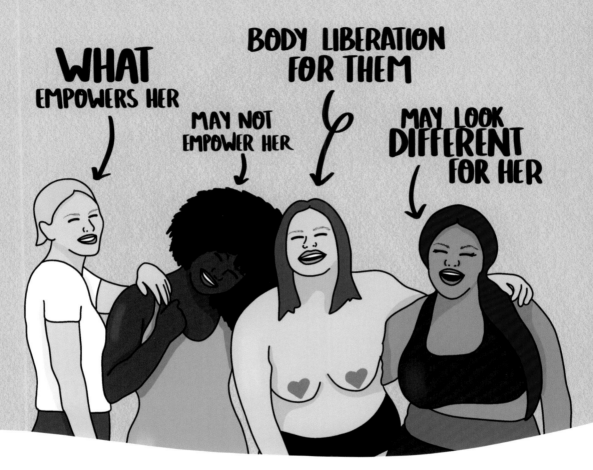

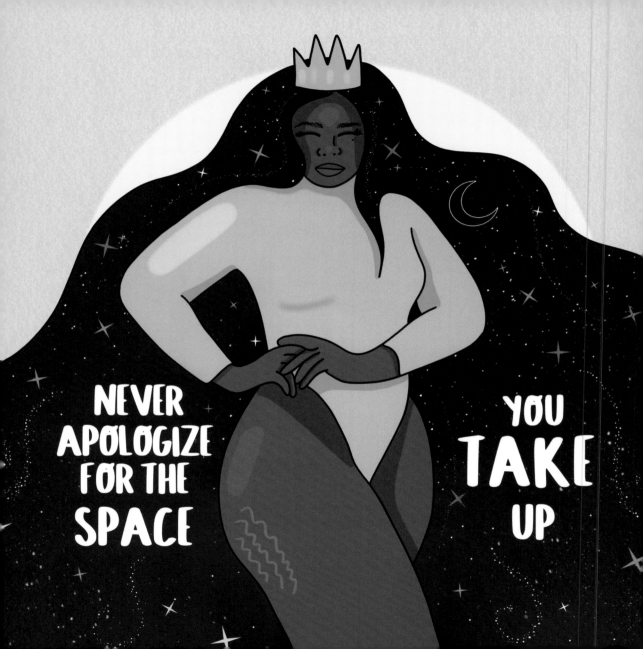

CLAIM *that* SPACE

LOOK AT YOU HERE, TAKING UP SPACE—as you are, from where you are, in a place you deserve to stand. Your physical presence says it all. We can release the person, people, even voices in our heads that told us along the way that we don't deserve to take up space. We can let go of whatever made us feel like we have to apologize for our thoughts, feelings, and desires. We never need to apologize for any of it or carry the narratives of "too big" or "too much." Our bodies show up like only ours can, not someone else's. And we shine wherever we go.

LET'S LOOK DOWN AND SAY TO OURSELVES, "I DESERVE TO BE IN THIS SPACE BECAUSE I AM IN THIS SPACE. I AM WORTHY OF IT AND EVERYTHING THAT FLOWS THROUGH IT."

REDEFINE *the* RELATIONSHIP

OUR BODIES DO SO MUCH FOR US—and we are not even aware of a lot of it. Yet we show our gratitude by pinching them and deeming them unworthy. We hold ourselves to impossible standards that were not built to include everyone, but instead make us feel as if we are only good enough if our bodies fit into a certain mold. When we love someone unconditionally, it doesn't mean we like them every moment of every day. It means we respect their feelings and choose to show up for them. It means we recognize the space they take up in this world and their inherent worth. Our bodies deserve that love from us.

WE AFFIRM THAT OUR BODIES DESERVE RESPECT—FROM OTHERS AND FROM OURSELVES. WE PROMISE TO SHOW UP FOR THEM, EVEN IN MOMENTS WHEN WE MAY NOT LIKE THEM.

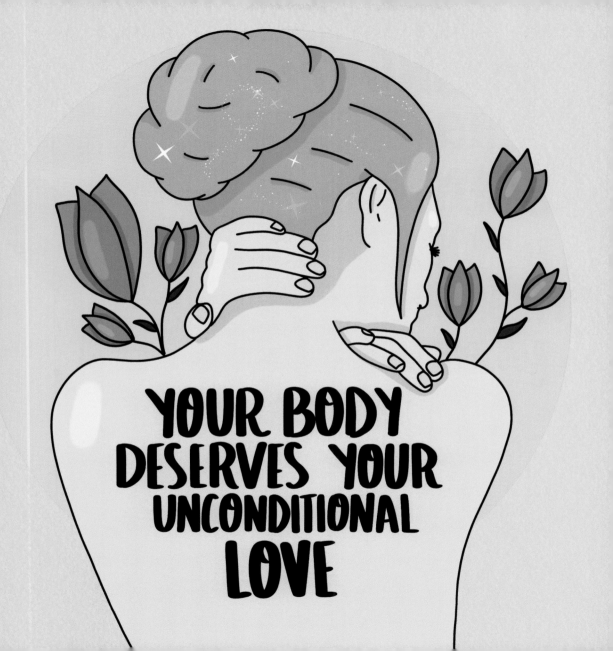

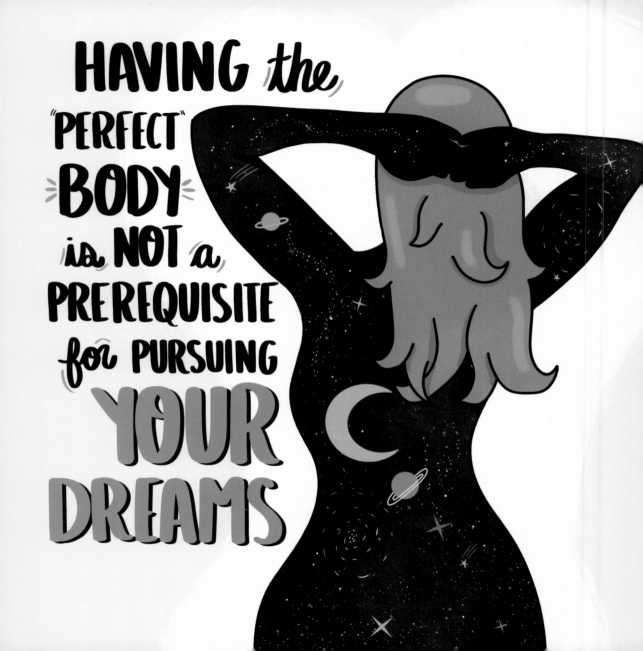

DREAM with YOUR BODY

HAVE YOU EVER OPTED OUT OF a dance, fitness, or other type of class because you didn't think you had the "right" body to participate? Or maybe you've turned down an opportunity to speak on a topic you're passionate about because you worried about how you would look in front of a social media or live audience? Join the enormous list of us who have experienced the same thoughts and feelings. How crazy it is to think that so many of us do not pursue our dreams simply because we think we need to "look the part" first! The truth is, we deserve to live our wildest dreams in whatever body we currently live in.

OUR BODIES ARE SIMPLY THE KEEPERS OF OUR MAGIC—EXTENSIONS OF WHO WE ARE BUT NOT ALL THAT WE ARE. WHILE OUR BODIES HOLD IT ALL TOGETHER, THEY ALSO DESERVE TO BE PART OF THE RELEASE AND REACHING FOR DREAMS.

ALLOW COMPLEX FEELINGS

THIS EITHER/OR WORLD GETS US BELIEVING that bravery can't coexist with fear. We somehow think that if we feel anxious, nervous, or emotionally wrecked, we cannot also be considered brave. But the ironic part is that we are most brave when we admit those unsteadying feelings and rise out of them, despite them. It's the moment in which we are vulnerable enough to share a hard but necessary truth or try something new—even when it disorients us. When we step out of that comfort zone, it's a process to move each foot over that line. Only we can move ourselves toward the goal, often down a path filled with all sorts of emotions.

IT'S TIME TO BEGIN TELLING OURSELVES, "I KNOW I'M SCARED IN THIS MOMENT, BUT I AM ALSO GOING TO CHOOSE TO DANCE WITH BRAVERY." WE CAN HOLD SPACE FOR BOTH EMOTIONS—AND THE WAYS THEY GUIDE US.

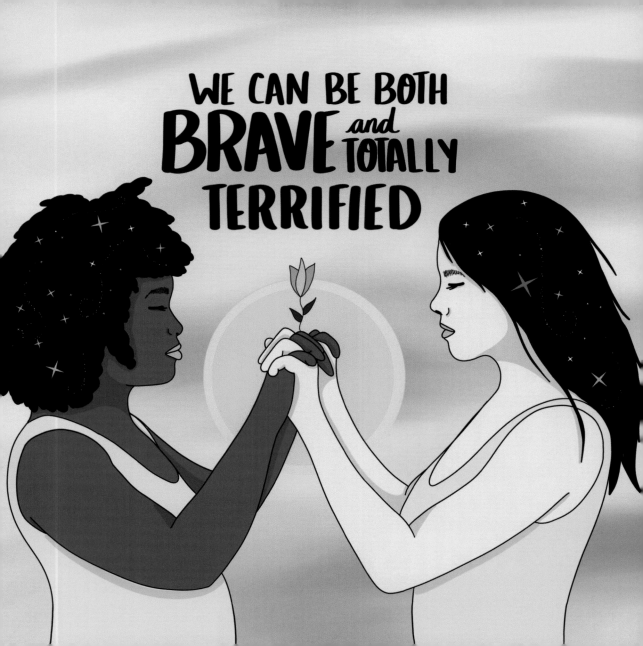

THE FEARS WE don't FACE BECOME our LIMITS

BE BRAVE *in* SELF-CARE

SELF-CARE EXTENDS WAY BEYOND FACIAL MASKS AND BATH BOMBS. It is so much deeper than that. Self-care can happen in moments when our knees are shaking but we choose bravery. In moments when our bodies are screaming "no" but our hearts are screaming "yes." In moments when we love ourselves so much that we face a fear in order to pursue a dream we've tucked away until now. In moments when we show up for that yoga class we were afraid of, we tell that person what we really feel, we set a boundary with a loved one we are afraid to lose.

WHEN WE MEET DIFFICULT THINGS HEAD-ON TO FEED OUR HEARTS, WE HAVE NEVER LOVED OURSELVES MORE. DISPLAYING THIS KIND OF BRAVERY IS THE MOST SACRED ACT OF SELF-CARE.

APPRECIATE ALL SEASONS

WHEN OUR BODIES NATURALLY SHIFT SO MUCH OVER TIME, how do we reconcile that fact with the media's insistence that we should push our bodies to look how they did when we were fifteen, nineteen, before pregnancy? We're being told to deny the most beautiful, *un*deniable truth about our bodies: that they change. They change to take care of us. They change to bring new life. They change because we have had the privilege of being on this earth longer. They change to send us loving reminders of how to care for them. Perhaps the best way to make peace with our bodies is to surrender to this flow instead of endlessly and destructively pushing up against it, to listen to our bodies instead of uninvested voices.

TOGETHER, LET'S TAKE TO HEART AND VOICE THAT OUR WORTH HAS NOTHING TO DO WITH THE EBBS AND FLOWS. OUR WORTH IS THE DEEP OCEAN, STILL, ALWAYS THERE, UNCHANGED BY THE CURRENTS.

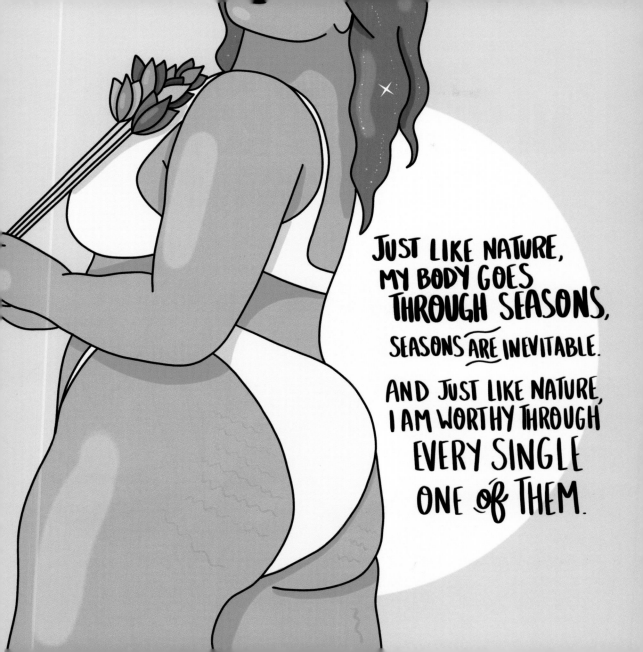

JUST LIKE NATURE, MY BODY GOES THROUGH SEASONS, SEASONS ARE INEVITABLE.

AND JUST LIKE NATURE, I AM WORTHY THROUGH EVERY SINGLE ONE OF THEM.

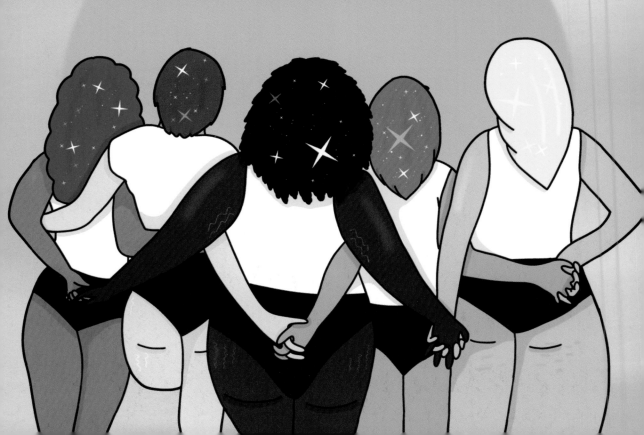

END the FABRICATED WAR

EARLIER IN OUR LIVES THAN WE MIGHT SUSPECT, we were exposed to images of girls and women with a very specific body type. There may or may not have been words on the pages or screens that labeled them "good," "beautiful," or "sexy." But the message was clear. What probably wasn't clear was where you fit into the picture if your body looked nothing like the popular images. (To be honest, even the models possibly didn't look anything like the published images.) What we begin to see are our bodies as problems—not reflected beyond our mirrors. With self-love and sister support, we can get to a place where we don't need to be at war with our bodies simply because marketing decided we should be—to benefit its bottom line.

HERE'S THE TRUTH: OUR BODIES WILL NEVER BE THE PROBLEM. WE ARE SO MUCH MORE THAN OUR BODIES, BUT OUR BODIES ARE ALWAYS GOOD.

STEP BACK *in* SUPPORT

WE OFTEN CONFUSE SHOWING SOMEONE SUPPORT through their experience with wanting to take it on ourselves. It's especially difficult to see the lines if you are easily empathetic or you see part of your own struggles in theirs. While it feels admirable to want to bear someone else's burden, taking too much of it on ourselves actually robs our loved one of the experience of navigating it themself. We need to allow for their own liberation to evolve and take shape. This is incredibly hard and has its own heartbreaks for us to navigate, but it is often what is needed the most.

WE ALL WANT TO BE HEARD AND SEEN, BUT WHAT WE REALLY NEED IS TO BE LIBERATED IN KNOWING THAT WE CAN DO REALLY DIFFICULT THINGS.

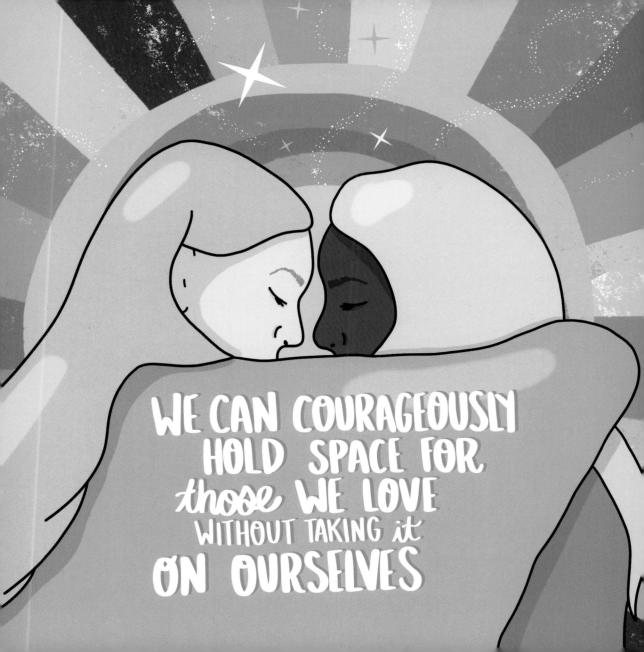

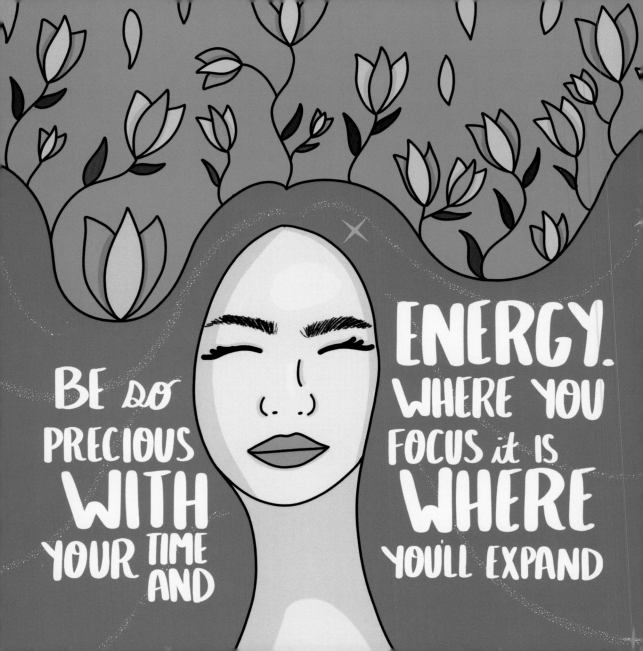

KNOW WHERE YOU WANT to GROW

OUR TIME IS THE MOST PRECIOUS THING WE HAVE on earth. We are only really here for a blip. The older we grow, the more we become aware of this and start to home in on how we use our finite time here. What we focus on is what will grow in our life. What do we want to flourish when we dig down deep into our desires? Spending time examining where we will put our energy and then keeping our promises to ourselves is self-care. Will we let the time slip away as we circle endlessly around where our heart lies? Or will we invest in relationships, fueling our souls, and healthy growth?

THE SEEDS FOR BEAUTIFUL, STRONG GROWTH ARE IN OUR HANDS WHEN WE PUT IN THE TIME AND ENERGY TO NURTURE ALL THAT CAN BE IN OUR LIVES AND SUPPORT EACH OTHER IN SOUL-FREEING CHOICES.

SET HEALTHY
SELF-LOVE GOALS

WE HEAR AND READ SO MANY MESSAGES around what self-love is and what it isn't, how we should feel and shouldn't feel. This right/wrong, black/white perspective can make us question how good of a job we're doing when we're not in sync with our inner magic through every moment of our lives. The truth: self-love isn't flipping a switch, one and done. Self-love is a muscle, a practice, a discipline. It's not never having doubts or down thoughts. It's knowing that no matter what thoughts float about the surface, we are still worthy. It's knowing that we are valuable, and that we matter.

A HEALTHY DEFINITION OF SELF-LOVE CENTERS AROUND A CORE BELIEF THAT YOUR WORTH IS NEVER UP FOR NEGOTIATION—EVEN IF YOU ARE THE LEAD NEGOTIATOR. WE MAY NOT WAKE UP KNOWING IT OR FEELING IT EVERY DAY, BUT WE CONTINUE TO BUILD AND REBUILD AS NEEDED.

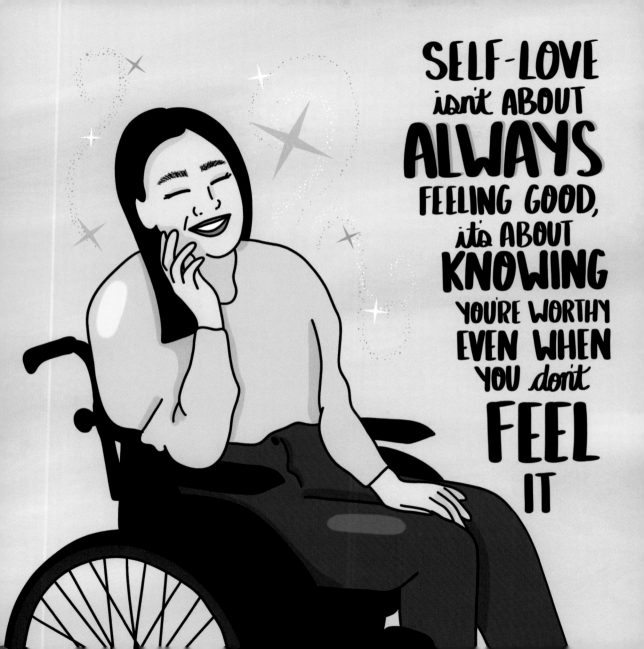

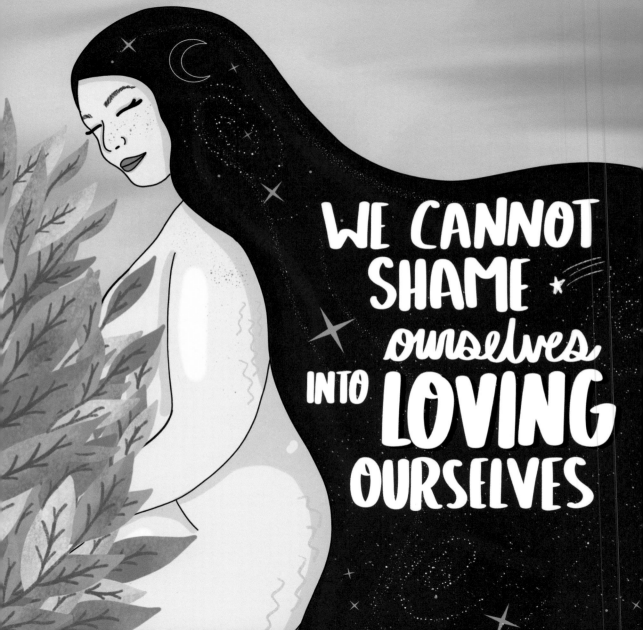

GROUND CHANGE in LOVE

IF WE COULD SOMEHOW SHAME OURSELVES INTO LOVING OURSELVES, we would all be swimming in piles of self-love hearts by now. Think about the number of times we have tried to hate ourselves into a specific body. Consider how often we beat ourselves up for mistakes, believing that's the secret exit from living as a flawed human. If only we can rub our noses in it, we can produce a more desirable outcome. But shame wounds us, even paralyzes us. It slips messages into our minds— telling us we are not good enough and that we deserve to feel terrible. If any intention is from a place of shame, it will never produce a loving outcome. Instead, we can choose gentleness and curiosity as a path.

WHEN WE WANT TO CHANGE SOMETHING IN OUR LIVES, WE CAN SAY TO OURSELVES, "I WANT TO DO BETTER BECAUSE I BELIEVE I CAN." LET THAT BE THE FOUNDATION FOR US EVOLVING.

LISTEN to the LOVING VOICE

HOW MANY TIMES HAVE WE HELD OURSELVES BACK because we listened to that loud voice that shouts at us that we are somehow not deserving of a life full of abundance? It's the one that sneaks in when we have a moment of self-doubt. We hear it say that we are not deserving of success simply because we started from a different place than someone successful did. We hear it say that we are not deserving of happiness simply because we are humans who, upon reflection, learn that we could have done something better. We hear it say that we don't deserve joy, and if we really allow ourselves to lean into it, we may be revealed as an impostor and lose everything. Or perhaps something that happened to us or was said to us led us to believe we are unworthy. All of these voices talk us out of believing that we are just as deserving as anyone else, and none of them is there to love us.

LISTEN TO THE QUIET, LOVING VOICE, THE ONE DEEP WITHIN THAT WHISPERS TO US IN MOMENTS WHEN WE LOOK UP AT THE VAST, ABUNDANT SKY. HEAR IT SAYING, "YOU TOO ARE JUST AS DESERVING OF A BIG, BEAUTIFUL LIFE."

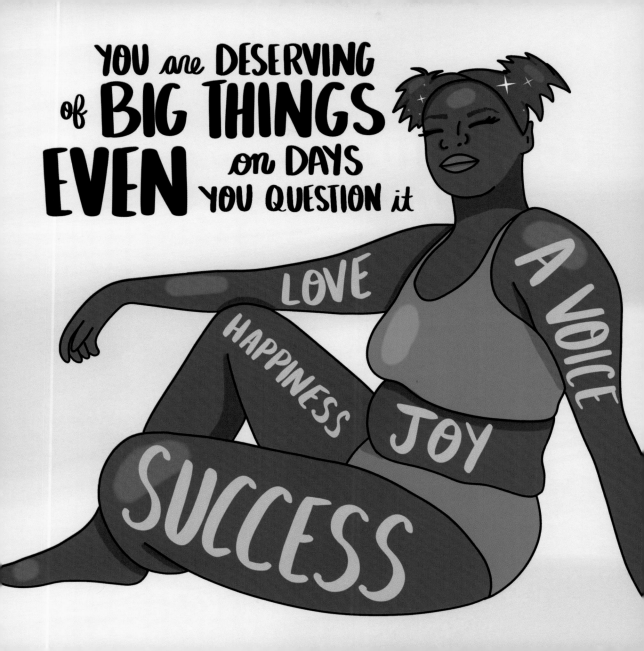

STAY CLOSE
TO THOSE
COMMITTED
to

SEEING
YOU AND
LOVING
YOU

FROM
WHERE
YOU ARE
AT ON
YOUR
PATH

HOLD ON *to* PURE LOVE

WE WILL COME UP AGAINST A LOT OF PEOPLE IN OUR LIVES who love the versions of us that they want us to be, not who we really are. And it's fair to say that we will experience times in our lives where we ourselves fall in love with people because we love *the idea* of them more than them. These feelings, and any actions that flow from them, don't make us "bad"; they make us human. But as we evolve, we hold to the truth that we deserve to be loved for who we are in any given moment. So sometimes, loving someone for who they are means walking away from them; other times, loving them is holding them tighter.

REMEMBER TO HOLD HANDS TIGHTLY WITH THOSE WHO WALK ALONGSIDE US ON OUR PATH. THOSE WHO SEE OUR STRUGGLES, OUR HUMANNESS, AND STILL WALK BESIDE US, ARE THE EMBODIMENT OF LOVE.

GIVE UP *the* HIDING

SHOWING UP TO LIVE OUR LIVES FULLY means that we will *feel it all*. And there is so much to feel! We are such complex and rich humans with layered experiences and emotions. That truth is absolutely the most beautiful thing about all of us, and it will absolutely break our hearts in the most beautiful way. But there is another stream of truth running right next to it: that going through those experiences and emotions will also undeniably break us open to so much that we can't even imagine. Once we've opened the gates, we don't have to hide ourselves anymore.

WE DON'T HAVE TO HIDE OUR FEELINGS. WE DON'T HAVE TO HIDE WHO WE REALLY ARE. WE CAN BE HERE, FULLY. WE CAN OPEN OURSELVES UP TO LIFE AND LET IT OPEN US IN BREATHTAKING WAYS.

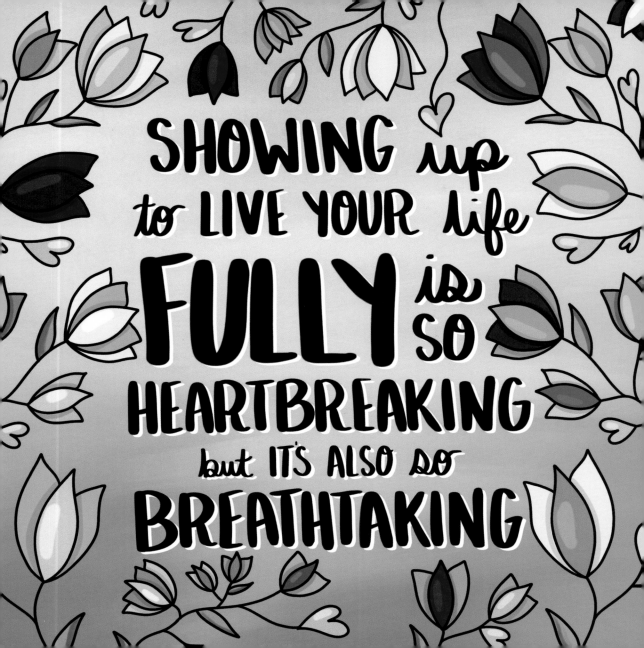

YOUR WORTH *doesn't* RESIDE on YOUR HIPS or THEIR CUTE WAVY DIPS

BREAK *the* LINK

HOW LITTLE TIME DID WE SPEND THINKING OF SOMETHING CALLED "HIP DIPS" before they were identified on social media? We just noticed that possibly our bodies dipped that way. Then after the naming ceremony, there came a flood of ads for products, diets, and exercises to ditch those dips. Suddenly, the thing we didn't even know had a name was our enemy. Diet culture was hard at work again, profiting off our bodies and our insecurities. The damaging message: our best, most worthy self is linked to how our body looks. So begins the obsessing and believing that if we change our bodies, then we will find happiness (like the images we see in the ads) and become more deserving of love. But we have the power to break the link if we supersede it with a self-love message.

WHILE ATHLETIC GOALS AND BODY AUTONOMY ARE BEAUTIFUL, OUR WORTH WILL NEVER LEAN UP AGAINST OUR BODY SIZE OR SHAPE. CERTAINLY, THE LOVE WE DESERVE WILL NEVER BE LINKED TO IT.

FOCUS on SHINING

WHEN WE REFLECT UPON THE PEOPLE WE LOVE AND WHY WE LOVE THEM, we don't think about how we love them because of the shape of their body. No one is going to stand up at your funeral and list off all the ways you had a "hot bod." People won't remember your current measurements or how small your waist was at one point. They *will* remember how you made them feel: how you showed up for them, how you loved them, and perhaps how you helped them see the light in themselves in moments when *they* didn't see it themselves. They will remember what you cared about, where you placed your time and energy, and what ignited your passion and made you shine.

PEOPLE WILL REMEMBER YOU FOR THE MAGIC YOU BRING INTO YOUR LIFE, OTHERS' LIVES, THE WORLD. YOUR BODY SIMPLY CARRIES YOUR MAGIC.

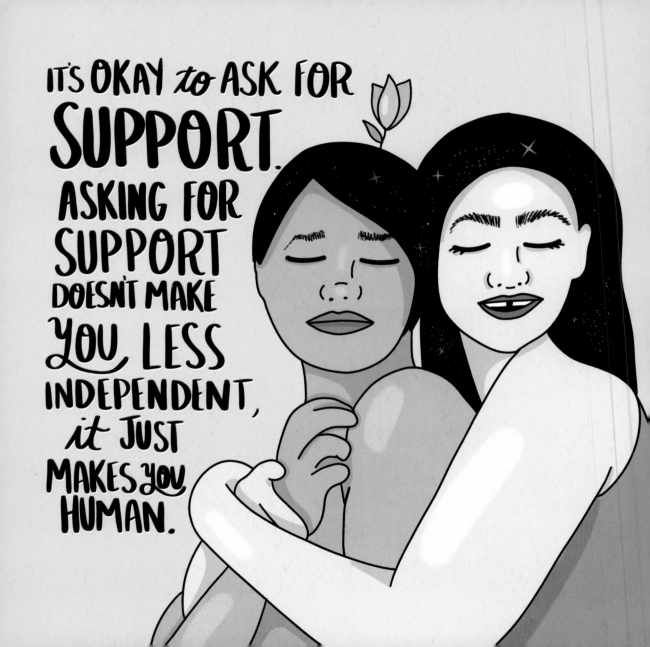

REACH OUT in STRENGTH

WE DON'T HAVE TO DO IT ALL ON OUR OWN in order to be independent. Asking for help when we need it doesn't make us emotionally fragile; it makes us humans who need some hands to help lift us up. Sharing what we are going through with others so that they can listen and assist us is a brave act of surrender and self-care. It's loving ourselves enough in the moment to know that we can't figure out everything on our own. Asking for what we need can be so hard but so necessary.

ASKING FOR SUPPORT DOESN'T TAKE AWAY FROM OUR INDEPENDENCE; IT ONLY STRENGTHENS OUR ABILITY TO SPEAK UP FOR OURSELVES AND OUR NEEDS.

DROP *the* COMFORTABLE ROLES

THIS MESSAGE GOES FAR DEEPER THAN JUST NOT FEELING THE NEED to keep our bodies small. It's also about not keeping our voices, our presence, our influence small. It's about *all* the ways women play small in our lives, in a self-sabotaging way, in order to not make other people feel uncomfortable or intimidated. If we play the good girl card—small, complacent, quiet, not overly opinionated—we can keep the room happy with us. Everyone seems comfortable. But our liberation will never be found in playing a role in order to appease those who only really care about who we are in their minds, not who we really are.

WE CAN'T PLAY SMALL WITH OUR LIBERATION AND IDENTITY. TRUTH IS GREATER THAN PERCEIVED COMFORT—IN OUR LIVES, IN OUR WORLD. WHEN WE'RE AUTHENTIC, WE CAN GO FAR—TOGETHER.

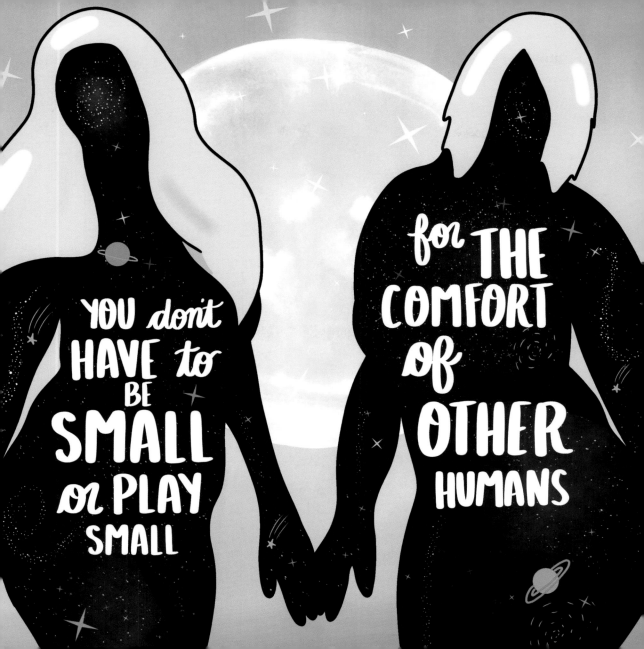

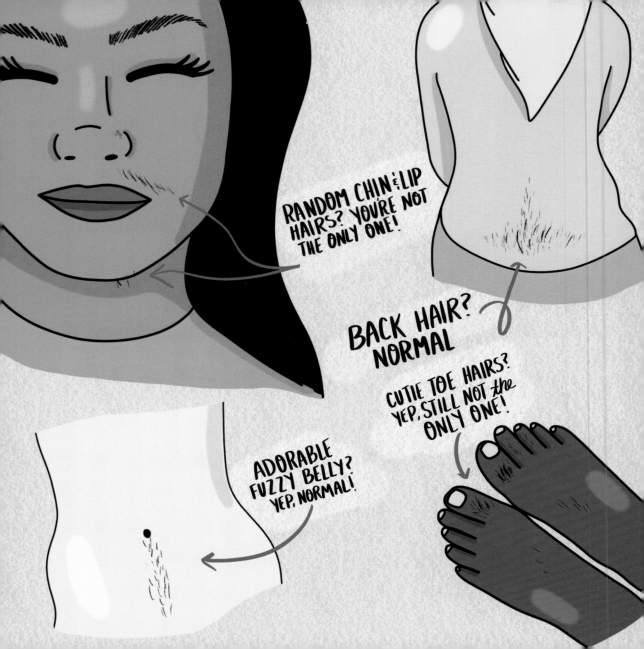

NORMALIZE *those* HAIRS

HAS THAT ALWAYS BEEN THERE? WHERE DID THAT COME FROM? Oh wow, look what can be seen only in the car mirror! Random, protruding hairs of all lengths, colors, and coarseness are completely normal. There are nipple hairs, toe hairs, chin hairs, belly hairs, back hairs.... Wherever hair decides to hang out on our bodies, it's normal and what we do with it is an individualized, personal decision. Keep it? Cool! Shave it? Awesome! Laser or wax it? Great! Now that we've uncovered its normalcy, we can move on to bigger, more important things in our lives. Wonderful!

YEP, HAIR IS THERE—NATURAL, NORMAL, NOT ALONE IN GATHERING ON OUR BODIES. CHOOSE HOW TO VIEW IT, THEN LET YOUR MIND AND ENERGY MOVE ON.

SHOW UP *for that* INNER CHILD

AS KIDS, WE BASK IN THE GLOW OF MOTHER NATURE, freely playing in her abundant love. But then one day, we look over and see our bodies may not look like that other girl. We pull the towel around us, apologizing to the world for how we show up in it and denying ourselves the simple pleasure of letting nature shine on us. If we are not mindful, we can spend our whole lives believing that we are never good enough to deserve peace with our bodies. We miss out on the magic of existing in the moment, as we are. Perhaps we can choose another path—the one where we connect with that girl who longed to just explore and play in this big beautiful world.

WE STILL CARRY OUR INNER CHILD WITH US. REACH IN TO THE INNER CHILD IN YOU WHO KNOWS THIS WORLD IS HERS TO DANCE AROUND IN— HOWEVER SHE LOOKS WHEN SHE SHOWS UP IN IT.

THE LITTLE GIRL IN YOU, THE ONE YOU ONCE WERE, DOESN'T CARE WHAT SHAPE HER BODY TAKES AS SHE CHARGES INTO THE WATER. SHE ONLY CARES ABOUT THE EXPERIENCE SHE IS ABOUT TO HAVE WITH MOTHER NATURE KISSING HER SKIN AND WASHING THROUGH HER TOES. SHOW UP FOR THIS LITTLE GIRL—THE ONE YOU STILL CARRY INSIDE YOU.

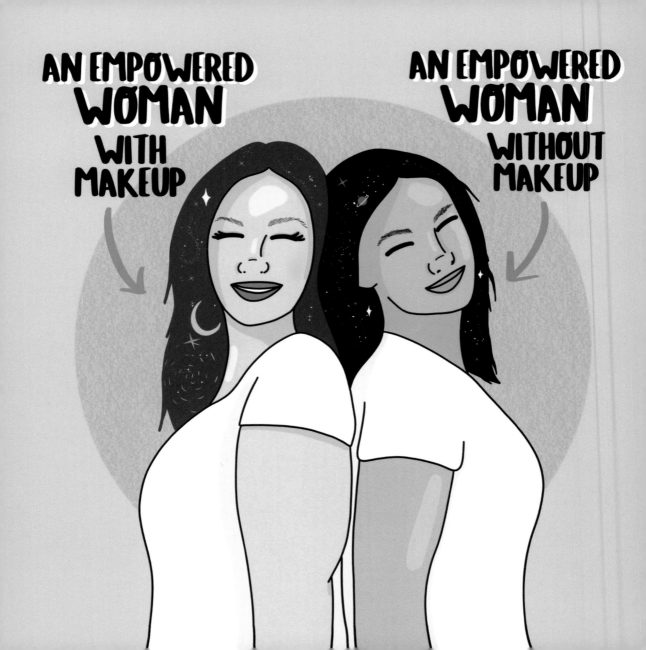

CHOOSE what EMPOWERS YOU

MAKEUP, LIKE ANYTHING, CAN EITHER EMPOWER OR DISEMPOWER an individual. It can make us feel creative, fun, and confident; its application can even be a form of self-care. But at the same time, makeup can also be something that makes us feel less than, like we are not enough on our own; it can cause us to lean into our insidious perfectionism. The only person who really knows whether it empowers you or not is you. No one has the right to an opinion on what we do with our body. What works for us or doesn't is our decision to make. If a full face of makeup empowers you, fabulous. If being bare-faced makes you feel more you, wonderful.

ALWAYS CHOOSE THE PATH THAT MAKES YOU FEEL CLOSER TO YOURSELF. THAT IS WHAT EMPOWERMENT IS REALLY ABOUT, AND IT LOOKS DIFFERENT FOR EACH OF US.

ACCEPT HUMAN QUIRKS

THERE ARE OFTEN TIMES IN OUR LIVES WHEN WE THINK WE ARE ALONE in very human experiences, only to find out that there are so many people who are going through the same experience. We think we are the only ones who tug on our hair when we are anxious, bite our nails to self-soothe, or lose our train of thought when we are nervous—not even close. And when we see these little habits and traits in others, we don't blink an eye. We would never deem them unlovable or shame-worthy. Why are we so hard on our own responses and ourselves?

OUR HUMAN EXPERIENCES AND RESPONSES ARE JUST THAT: HUMAN. LET'S SEEK TO APPROACH OURSELVES WITH GENTLENESS AND THE SAME GRACE WE WOULD OFFER OTHERS GOING THROUGH A DIFFICULT TIME.

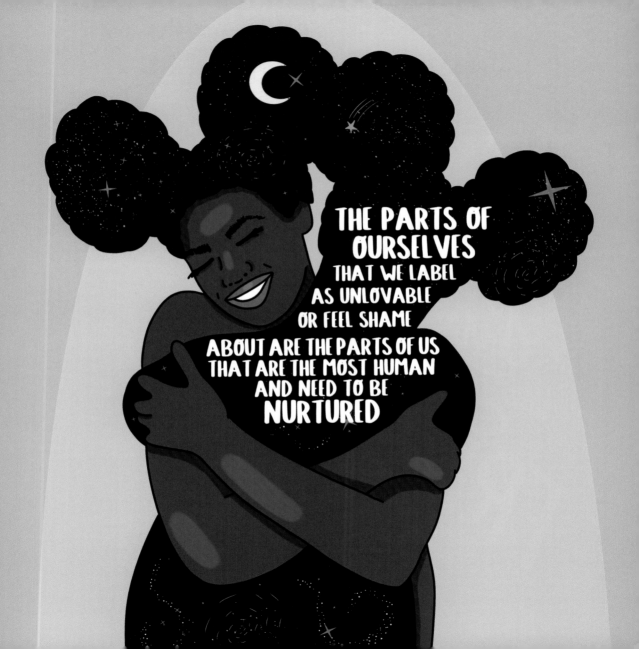

INCLUDE YOURSELF in LOVE

HAVE YOU EVER POURED YOUR COMPLETE ENERGY AND WHOLE HEART into someone else only to find yourself feeling lost and empty of love? Reflecting on the experience, we often see that all of the love that we wanted to give to someone to make them feel good enough, secure, and desired was what we should have been pouring into ourselves. We needed all of those feelings of value, all of that investment, too.

WE CAN BEGIN TO SHOWER OURSELVES WITH LOVE IN THE SAME WAY WE UNHESITATINGLY GIVE IT TO OTHERS. IT'S NEVER TOO LATE.

TIE SELF-CARE with SISTERHOOD

SUPPORT HAS A RIPPLE EFFECT THAT BLEEDS INTO EVERYTHING WE DO. I am here, writing this book, because of those who have believed in me in moments when I haven't believed in myself. Those who offered me a hand from on top of a mountain that they have already climbed. We often talk about self-care in a language that just centers on us and how it benefits us, but self-care benefits sisterhood and those we help, too. When we tend to our needs, we create space to lift up even more women who are in line behind us and who need us. The goal, after all, is to make sure everyone is able to reach the top.

SELF-CARE IS KNOWING WHEN TO CLIMB A MOUNTAIN OURSELVES AND GATHERING THAT STRENGTH. SISTERHOOD IS LOOKING BACK AFTER WE CLIMB AND OFFERING OUR STRENGTH TO HELP SOMEONE ELSE UP. THEY ARE NOT INCOMPATIBLE.

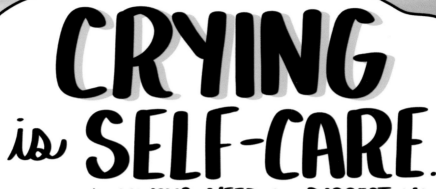

FREE your FEELINGS

WE SO OFTEN THINK THAT IF WE ARE FEELING ANY HEIGHTENED EMOTION, we need to "fix" something. While sometimes our emotions can be an inner signal that we need to reflect on an area of our life, most of the time they are just our body's longing to feel and express in order to find healthy release. That can be difficult for us to see in the moment. It may feel like an emotion will last forever. We forget that it is *just* an emotion *in motion* through our bodies. If we can let it flow without judgment, and without the impulse to fix something, we can experience release. We can get out of our own way.

IT'S OKAY TO CRY. IT'S SAFE TO CRY. WE NEED SPACE TO FEEL AND RELEASE. SOMETIMES LOVING OURSELVES IS SIMPLY REMINDING OURSELVES OF THAT AND ALLOWING OURSELVES TO CARRY THROUGH WITH OUR EMOTIONAL NEEDS.

LET GO of EMOTIONAL TRIAGE

WHY DO WE UNCONSCIOUSLY BELIEVE THAT EMPATHY IS FINITE when we compare our suffering to the suffering of others? We get caught up in comparing our pain to others' in order to decide whether we are worthy of experiencing the heaviness of what we currently feel. If we feel someone "has it worse," we shut down our experience and justify it by saying, "But so many people have it worse, so I shouldn't feel this way." But there is a flaw in this belief system. While it makes us believe we are being more empathetic, it actually robs us of fully stepping into our most empathetic selves. So let's bring in a new belief system laced in the truth of our valid feelings.

WHEN WE FEEL VALIDATED IN OUR OWN EXPERIENCES, WE OPEN THE DOOR TO FEELING MORE EMPATHY TOWARD OTHERS. WE ARE ABLE TO SEE OURSELVES IN THEM AND OFFER SUPPORT WITHOUT STEPPING OVER OUR OWN NEEDS AND FEELINGS FIRST.

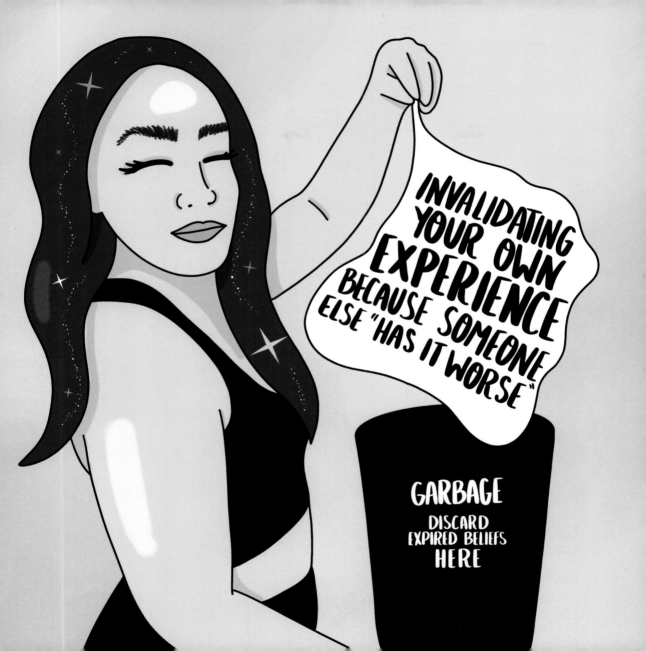

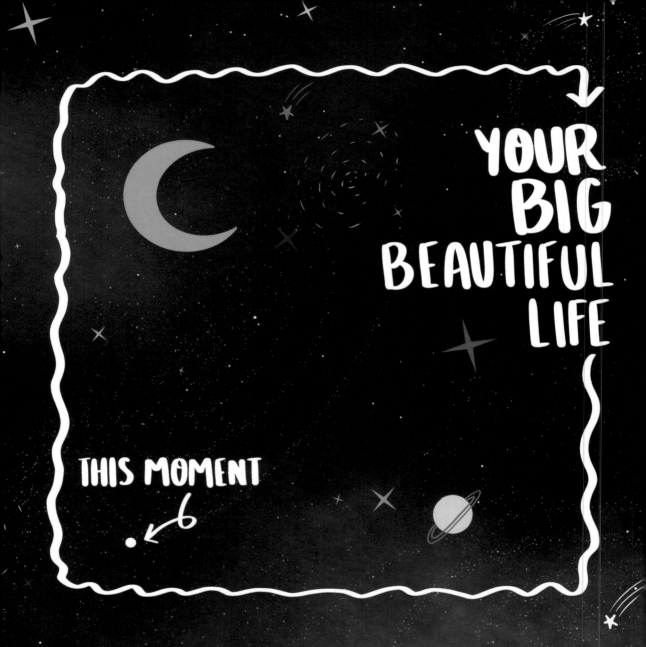

YOUR
BIG
BEAUTIFUL
LIFE

THIS MOMENT

LOOK TO *the* WHOLE GALAXY

WE HAVE ALL HAD MOMENTS WHEN WE DIDN'T FEEL LIKE we would make it through. Remember one of those times? Well, look at you now—here, breathing, and still standing after all. The truth is, there will be another time you will hit that rocky road and declare to yourself, "I can't make it through this!" But you will. Those times are the little stars burning out from far away in the giant galaxy that is your life. Our lives are so big and those dark moments are only a small part of our stories. Sometimes we really don't see a way through—and that's okay. We don't have to see it to know it's there—the same way we can't always see or feel the sun on our skin but we know she is always there, cheering us on.

DON'T LET DARK LITTLE MOMENTS BE BIGGER THAN THEY ARE. WE CAN GIVE OURSELVES PERMISSION TO FEEL THEM, SIT WITH THEM, AND THEN PICK OURSELVES UP AND KEEP WALKING. THEY ARE ONLY MOMENTS OF OUR LIVES; THEY ARE NOT OUR LIVES.

EMERGE into the WAITING WORLD

WHILE WE WASTE TIME "BODY CHECKING" OURSELVES IN THE MIRROR, the world outside the window is waiting for us to show up. The world never asked us to be perfect, or a certain size—that message came through other people and within ourselves. The world just wants us to be in it, explore it, play in it, trust it. It doesn't ask us to change who we are; it only asks us to evolve and love ourselves from where we are at. The world invites us to fall in love with our present self, not miss out by chasing future or past versions of ourselves (or versions of ourselves that someone else told us we needed to be).

WE DON'T HAVE TO KEEP OBSESSING OVER OUR BODIES. LET'S PUT DOWN THAT BELIEF SO WE CAN EMBRACE THE LIFE WE'VE BEEN GIVEN, IN THE HERE AND NOW, AND JUMP BACK INTO THE WORLD.

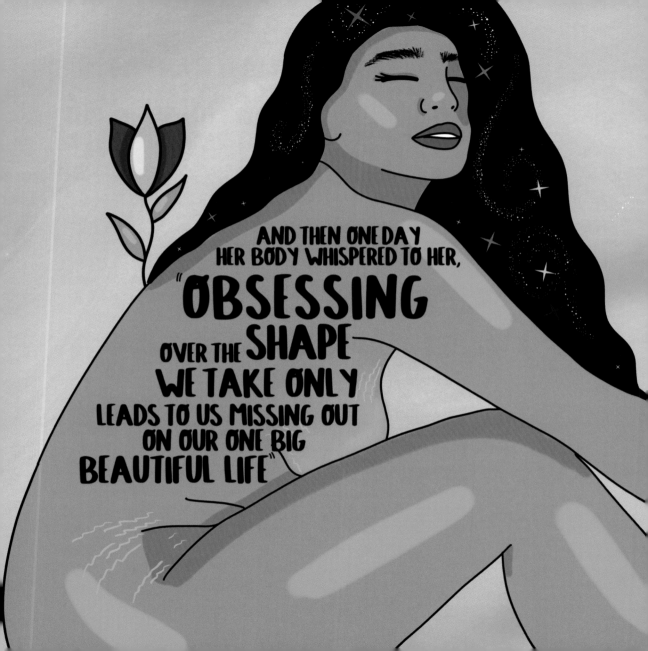

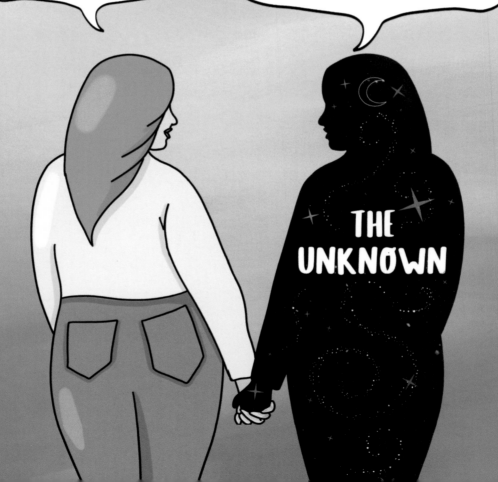

WALK into the UNKNOWN

THERE ARE TWO WAYS WE CAN ADDRESS THE UNKNOWN. We can inch toward it in total fear, letting that feeling stop us from dreaming big and trusting the magical darkness. Or, we can know that fear of the unknown is one of the most human experiences and lean into it—sweaty palms and all. In order to embrace the unknown, we often believe we have to get rid of all fear. We imagine ourselves overcoming fear and *then* walking forward. But that never really works, does it? If feelings of fear pop back up, we think we somehow failed and use it against ourselves moving forward. But what if we embrace fear and choose to just walk beside it?

OUR PATHS FORWARD DEPEND ON REMINDING OURSELVES THAT SO MUCH MAGIC RESIDES IN THE MYSTERIOUS, DARK, UNKNOWN PARTS OF OUR LIVES. WE CAN GIVE THE UNKNOWN PERMISSION TO BE UNCOMFORTABLE AND STILL WALK THROUGH THAT DOOR.

REDISCOVER your DREAMS

AS KIDS, DREAMS FLOW THROUGH OUR MINDS ALL THE TIME. We don't question whether they are possible. Instead, we live in the place between curiosity and possibility. That slowly starts to change as we lean more toward what we are told (and begin to believe) is "realistic." But the truth is, our dreams and the stories that fuel our dreams matter. Even if many people before us have realized their dreams that look like ours, our dreams still need us and we need our dreams.

HONORING THE PATHS IN OUR DREAMS BRINGS UP A WELL OF POSSIBILITIES. WHEN WE ALLOW OURSELVES TO FOLLOW WHAT WE DESIRE, WE NURTURE OUR SELF-WORTH AND GROW IN BEAUTIFUL WAYS.

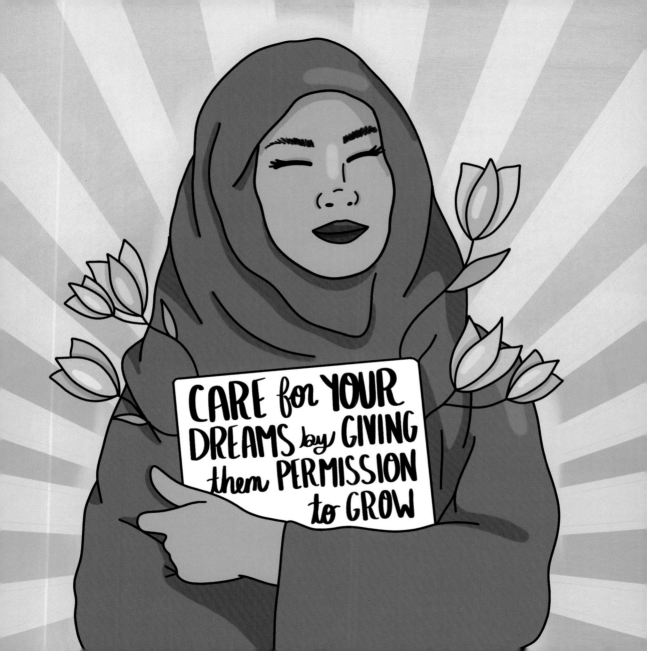

YOU don't NEED to LOSE WEIGHT before YOU CUT YOUR hair, WEAR that TOP, have PHOTOS taken OF YOURSELF, or SHOW UP for YOUR OWN LIFE

SHOW UP NOW, as YOU ARE

HOW MANY STEPS AND DECISIONS, BIG AND LITTLE, HAVE WE PUSHED OFF because we were waiting to be at the "perfect" weight? That haircut you want doesn't need you to change yourself first. Those photos are meant to capture you, where you are on your path right at this moment in time—not some version of yourself that you think you should be. We deserve to live our lives fully and show up for the things we want without needing to change ourselves first. Our lives are not conditional, based on fictitious or future identities. Our lives are now.

WE CAN REMIND OURSELVES THAT WE WANT TO BE EVIDENCE OF LIVES WELL LIVED. IF OUR ACTIONS COME FROM THE SPACE OF BELIEVING WE NEED TO BE DIFFERENT THAN WE ARE IN A SINGLE MOMENT, THEN WE ARE NOT CAPTURING THE TRUE GLORY OF WHO WE ARE.

REALIZE *the* PERMISSION *is* YOURS

SELF-ACCEPTANCE IS OFTEN A WINDY ROAD with an abundance of litter on the roadside and obstacles along the way. We are constantly stopping and asking for permission to drive on the road at all and for instructions as to what lane others think we fit in best. We apologize by shifting our bodies, personalities, and feelings so that we don't take up too much space. But if we're ever going to arrive at our full selves, we can't rely on the world's permission. We can't wait for someone to tell us that they love us so that we can begin to love ourselves. We can't wait for others who look like us to get to where we dream of going. Our true liberation lies in us realizing that we hold the only permission we need to be who we were meant to be.

WE CAN CHOOSE TO NOT STAND ON THE SIDELINES OF OUR OWN LIVES WAITING FOR OTHER PEOPLE TO APPROVE OF US. WE CAN BE WHO WE HAVE BEEN WAITING FOR.

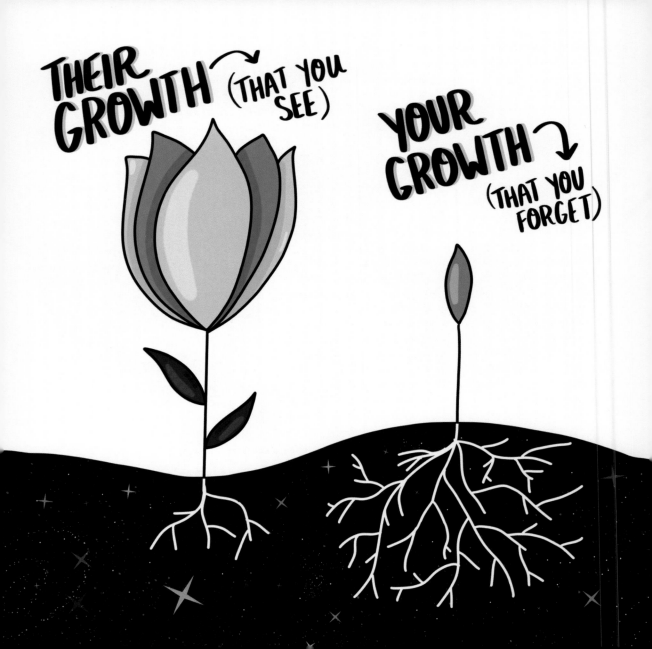

TREAT GROWTH GENTLY

IN THIS DIGITAL AGE, INSTAGRAM AND TIKTOK HAVE BECOME the primary lenses through which we view ourselves in relation to others. At a glance, we can see the growth someone else is having in one area of their life and jump to compare it to our own. We may try to figure out what we have done "wrong" to not see a similar type of growth in ourselves. We wonder how it came to them so easily. But scrolling is just a quick peek; it doesn't give us any indication of how deep the person's roots go or what time and nurture were put into the milestone. When we focus on surface comparison, we're robbed of valuing how we are growing—in ways both big and small, often deep below what the world can see.

GROWTH IS SLOW AND UNCOMFORTABLE; WE TEND TO LOOK FOR THE EASY WAY OUT OF IT. BUT IF WE CAN BE GENTLE AND PATIENT WITH OUR GROWTH, WE WILL CREATE A GARDEN THAT IS NOT EASILY AFFECTED BY THE WINDS.

COME EXACTLY as YOU ARE

THIS MESSAGE IS DEDICATED TO THOSE WHO HAVE BEEN TOLD they are too much, too emotional, too driven, too opinionated, too loud, too quiet, too [insert what you were told here]. All of those things are deeply a part of who we are and how we choose to show up for ourselves. People who make us feel like we are too much are just stuck in their own self-limiting beliefs around being too much. We can have empathy for them where they are, but we don't have to pick up that luggage and carry it as if it's ours.

WE ARE NOT TOO MUCH—NOT NOW, NOT EVER. WE ARE, IN FACT, THE PERFECT AMOUNT.

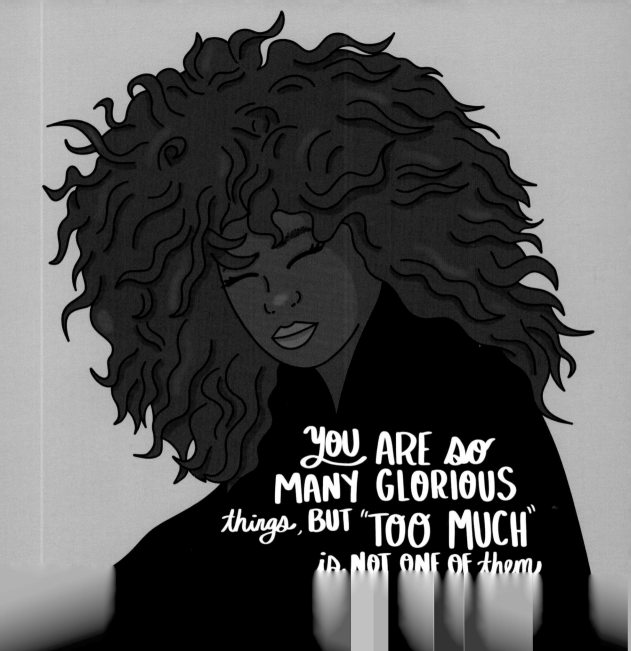

TAKE that RESTORATIVE BREATH

THINK YOU NEED MORE COFFEE? You probably just need to disconnect and rest. While our creativity, love, and success aren't finite, our capacity as human beings is. Our bodies, minds, and souls need rest—from our phones, our overstimulated world, and the stories we replay in our minds. Coffee or a positive quote won't keep us going beyond mere moments; we need deep rest to restore that magic inside. She is always in us, waiting for us, and will never leave. But our ability to see her will ebb and flow with our energy.

THE BEST WAY TO KEEP OUR MAGIC IN OUR VISION AT ALL TIMES IS TO ALLOW OURSELVES REAL REST. OUR DREAMS WILL NOT FADE AWAY IF WE TAKE A BREATH TODAY. IT'S OKAY.

UNCOVER *your* BODY'S STORY

WE WALK AROUND TELLING INTERNAL STORIES ALL DAY— stories about ourselves and the world around us. These stories are based on both personal experiences and the words and actions (both direct and indirect) of others. What story are you telling yourself about your body, and is it true? What stories do magazines tell us about those living in larger bodies? How does that reflect how we see our bodies? How has this system created a structure in which we place certain bodies on pedestals? Asking these questions can help us move away from damaging, false stories we have been taught to believe about ourselves *and* others. It opens us up to discover new stories that matter and lift up in sisterhood the stories of bodies that do not look like ours.

ALL BODIES HAVE AN EQUALLY VALID STORY. OUR BODIES' GROWTH, EXPANSION, GRIEF, PERSISTENCE, AND TRIUMPH MATTER AND SHOULDN'T BE SILENCED.

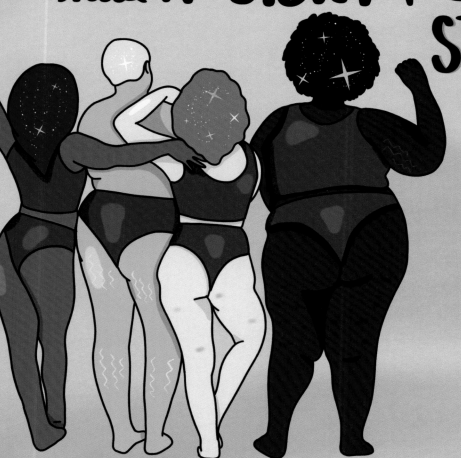

MAINSTREAM MEDIA Led US to BELIEVE THESE ARE the ONLY SOCIALLY ACCEPTABLE BOOBS:

BUT these BOOBS ARE EQUALLY MAGNIFICENT, WORTHY of BEING ADMIRED & JUST PLAIN COOL:

NORMALIZE ALL BODIES

MOST OF US WHO HAVE BREASTS HAVE LOOKED DOWN at one point or another, raised an eyebrow, and said, "Wait a minute. . . ." We realize that our boobs look nothing like what we saw on television or in magazines when we were growing up. Here's the thing: we all are entitled to change our bodies if we want to. You have that right, and no one has the right to shame you for it. It's your body, your life, your autonomy. If you choose to make a change, power to you. Another truth: your body does good and is good as it is. You don't have to change it, hate it, or manipulate it simply because it wasn't represented in media. Your body is your normal; therefore, your body is normal.

OUR BODIES ARE OUR OWN TO DISCOVER ALL THE WAYS IN WHICH THEY ARE BOTH NORMAL AND WONDERFUL.

END the ENDLESS FIXES

YOU HAVE ALWAYS BEEN AMAZING. The only thing wrong is the belief that there is something wrong. We spend so much time searching for what we need to fix. Constantly thinking we need to change ourselves, our emotions, our feelings, our bodies, is exhausting. Instead, let's lovingly take our own hand and pull ourselves off of that path. The new path isn't always easy—after all, self-acceptance can be a moving target. We are constantly and naturally changing and evolving and with that come new waves of what we have to practice accepting within ourselves. But the place of peace we come to is worth the effort.

LET'S TURN OUR EARS AWAY FROM THE NOISE OF THE WORLD AND LISTEN TO THE HEART-CENTERED VOICE INSIDE THAT TELLS US WE ARE AMAZING JUST AS WE ARE.

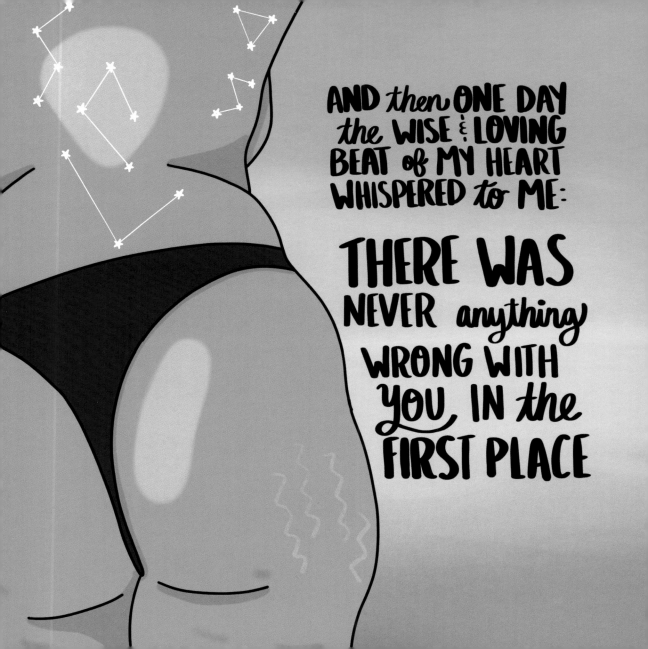

MEASUREMENTS ~~(crossed out)~~

FOLLOWERS ~~(crossed out)~~

JOBS ~~(crossed out)~~

LIKES ~~(crossed out)~~

NUMBERS
DO NOT DEFINE A
WOMAN'S WORTH

DEGREES ~~(crossed out)~~

GRADES ~~(crossed out)~~

WEIGHT ~~(crossed out)~~

SEXUAL PARTNERS ~~(crossed out)~~

MONEY ~~(crossed out)~~

KIDS ~~(crossed out)~~

CUT the TIES to NUMBERS

STEPPING ON THE SCALE AND IMMEDIATELY FEELING our self-worth drain from us is not a unique occurrence. The experience is bigger than us individually, and the significance of numbers on the scale is something we learned. Numbers on their own have no meaning. They are just floating bits of information on this earth that we grab and assign great meaning to. While it's not our fault that we have been taught to marry our self-worth with numbers, it is our responsibility to love ourselves enough to break the connection.

WE WILL NO LONGER TIE OUR SELF-WORTH TO FLEETING AND FLUID NUMBERS. WE DESERVE MORE THAN THAT. WE CAN GIVE OURSELVES MORE THAN THAT.

STAND *as* YOUR OWN HERO

YOU MADE THE DECISION TO PICK UP THIS BOOK because you know this self-love message is true. This book only reminded you of what you already knew: you are the hero of your own story. You have the capacity to unbecome everything you've been taught you have to be, including what you've told yourself you need to be, in order to become a truer, more beautiful version of yourself. After all, we lift each other up as much as we can until we see that we are also our own sister lifting ourselves up.

TOGETHER, WE TAKE STEPS EVERY DAY TOWARD BEAUTY, BRAVERY, AUTHENTICITY, EMPOWERMENT, GROWTH, SELF-ACCEPTANCE, LIBERATION, DREAMS . . . OUR OWN MAGIC UNLEASHED INTO THE WORLD'S EMBRACE.

YOU WERE ALWAYS WHO YOUR YOUNGER SELF WAS WAITING ON, YOU WERE ALWAYS MEANT TO BE THE HERO OF YOUR OWN STORY

MEET the AUTHOR

STEPHANIE CHINN is on a mission to spark important conversations about body confidence and female empowerment through her art and writing. Her work focuses on illustrating the different ways we can remind ourselves we are enough the way we are while simultaneously unpacking the different ways we have been led to believe we are not. You can find her tender reminders to love and care for ourselves and inspiration to unapologetically discover and unleash our inner magic on social media, including Instagram: stephaniechinnart. Stephanie has also contributed to *Health Magazine*, *Yoga Journal*, and *Fitness for Every Body: Strong, Confident, and Empowered at Any Size.*